The

VICTORIAN WOMAN

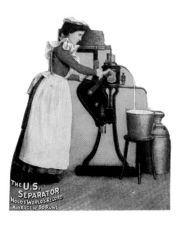

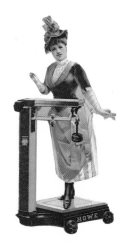

The VICTORIAN WOMAN

A BOOK OF DAYS

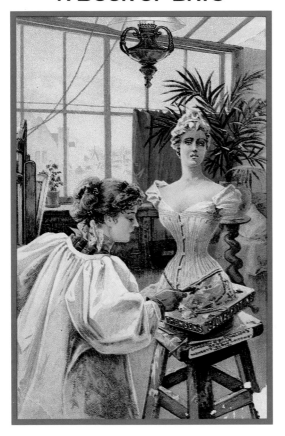

PICTURE RESEARCH AND TEXT BY
SALLY FOX

A NEW YORK GRAPHIC SOCIETY BOOK
LITTLE, BROWN AND COMPANY, BOSTON

DEDICATION

TO THE MEMORY OF BERNARD KARPEL, FORMER CHIEF LIBRARIAN OF THE MUSEUM OF MODERN ART (NEW YORK), WHO INSTILLED IN ME HIS OWN DELIGHT IN DISCOVERING THE COUNTLESS WAYS HISTORY CAN BE DOCUMENTED

COVER: DIE-CUT DISPLAY CARD. CIRCA 1890–1900. COLLECTION THE MARGARET WOODBURY STRONG MUSEUM, ROCHESTER, NEW YORK

CLEARLY, THE PROPER AND PRIM CLOTHING OF THIS YOUNG LADY CANNOT DISGUISE THE ROBUST SEDUCTRESS UNDERNEATH, DANGLING HER TEMPTING FRUIT.

TITLE PAGE: TRADE CARD. 1897. (PRINTER: H. A. THOMAS & WYLE LITH, N.Y.) COLLECTION MAURICE RICKARDS

"THE GLOVE-FITTING CORSET . . . IS PERFECT, FOR IT IS . . . SELF-ADJUSTING, YIELDING SO EASILY TO EVERY MOVEMENT THAT THE WEARER IS UNCONSCIOUS OF ANY FEELING OF CONSTRAINT."

BACK COVER: LABEL. CIRCA 1900. (PRINTER: E. DERVAUX, H. LECLERQ, HALLUIN [NORD])

UNLESS OTHERWISE NOTED, THE EPHEMERA ARE FROM THE COLLECTION OF THE AUTHOR. WHEN KNOWN, THE PRINTER IS IDENTIFIED.

FIRST EDITION
ISBN 0-8212-1646-5
LIBRARY OF CONGRESS CATALOG NO. 86-63587

NEW YORK GRAPHIC SOCIETY BOOKS ARE PUBLISHED BY LITTLE, BROWN AND COMPANY (INC.)

PRINTED IN THE UNITED STATES OF AMERICA

ACKNOWLEDGMENTS

The author is grateful to the many collectors, dealers, and curators of ephemera who so enthusiastically shared their experience to assist her in documenting what, in many cases, is undocumentable. Four were outstanding with their generous advice: Professor Helena Michie, Brandeis University; William Frost Mobley; Stephen D. Paine; Maurice Rickards, FSIAD, Founder and Chairman, The Ephemera Society (UK). Especial thanks also to Anne Flavell, Curator, The John Johnson Collection, Bodleian Library, Oxford; Valerie Harris; George Harrison, Director, The History of Advertising Trust, London; William H. Helfand; Sharon and Daniel Kleitman; Lorene Mayo, Specialist, The Warshaw Collection of Business Americana, Smithsonian Institution; Robert Opie; Calvin Otto, President, The Ephemera Society of America; Deborah Smith, Curator of Paper, Margaret Woodbury Strong Museum; Rosina Stevens; Sharron Uhler, Curator, The Hallmark Historical Collection; and Collette Wampole. In addition, the author is grateful to the very helpful staffs of the following museums and companies: Baker Library, Harvard Graduate School of Business Administration; Campbell Soup Co.; Deere & Co.; Eastman Kodak; H. J. Heinz Co.; Library of Congress; Metropolitan Museum of Art, Jefferson R. Burdick Collection; Museum of Fine Arts, Boston; Museum of London; Nabisco Brands; New-York Historical Society, Bella C. Landauer Collection; New York Public Library; Procter & Gamble Co.; Schlesinger Library, Radcliffe College; Science Museum, London; Smithsonian Institution; Victoria and Albert Museum.

Finally, the author deeply thanks her husband, who so eagerly shares her enthusiasm for this reseach.

❄

The New York Graphic Society again deserves thanks for appreciating and publishing the results of new research into pictorial documentation of history. Special gratitude is reserved for Betty Childs, a most professional, imaginative editor, who understands and enjoys the purpose of picture research.

The VICTORIAN WOMAN
AND THE NEW ADVERTISING AGE

How is the past documented? Usually major national and international events and people in power leave a trail of papers and artifacts to make up what we think of as documents of "history." The farther back in history, the more important any document becomes, no matter how minor. But as we come closer to our own time, we tend to disregard as meaningless and trivial everyday papers and artifacts, when, in fact, they can record and illustrate our own immediate past as significantly as any laundry list does for the Egyptian era. Social historians are becoming more aware of the importance of these everyday documents—usually printed—that were intended to be used, then thrown away. These materials, known as "ephemera," are now being collected and examined seriously as illuminating documents of our past and present. The illustrations in this book, late nineteenth-century advertising ephemera in many forms—trade, or advertising, cards, posters, labels, magazine insets, and more—throw light on the roles of women in the late Victorian era. ❧ As the nineteenth century progressed, new power sources and inventions led to increasing urbanization and the expansion of transportation facilities and factories. Mass production, merchandising, and distribution systems were introduced and developed into forms still used today. Marketing concepts such as brand names, company images, and targeted markets were identified and exploited to compete more effectively for specific audiences. Though advertising had existed for centuries, the Advertising Age as we know it today began in the late Victorian period in synchrony with the Age of Invention and, with it, Consumerism. ❧ This expanding economy changed the accepted roles of men and women. The more that men went outside the home to work in industry to earn wages, the

more women were left to work at home, isolated and unpaid. The role of housewife, as we know it today, developed simultaneously with industrialization and the growing middle class. Supposedly impervious to the noise and bustle of industrialization, the Victorian home, and the housewife who embodied it, came to symbolize a safe and peaceful alternative to the marketplace in which men worked. Despite this idealization of the home and women's role within it, the marketplace did indeed intrude upon and help to shape the lives of women. Ironically, advertising, formed in and for the marketplace, was a significant factor in persuading women that the home was sacrosanct and that their role was to stay within its walls. ❧ Advertisements, which then as now depended heavily on images of women, helped to define women's roles by dictating both the tools they were to use in producing the ideal home and the way they were to spend their time. The varieties of work illustrated by these ads were the work of women based on perceptions of their past roles, their actual occupations during the Victorian years, and their expected work in the future. ❧ Recent research has revealed that most of the new household inventions did not, in fact, "make life easier" for women. Many of the new technologies and inventions helped to reduce some of the household drudgery, but the time and effort expended often increased as a result of the rising expectations that accompanied the introduction of these new tools. As the hand-powered washing machine became available for the home, the standard for cleanliness rose, demanding more laundering. The iron industry produced the cast-iron stove, eliminating the difficulties of cooking over a fireplace, but, in turn, demanding greater variety of cooked and baked foods, as well as polishing (!) the stove. ❧ Advertising ephemera was also aimed at women other than married housewives: single servants, factory workers

and the growing number of office employees. As the century drew to a close, the domestic class in the United States diminished greatly, since immigrant women, whose ranks had been the source of servants for middle-class American housewives, preferred to work in the developing industries: factory work, in spite of difficult conditions, promised them independence, fixed hours, and needed cash. This movement away from domestic service occurred in Britain more than a generation later, when servants went into factories as temporary replacements for the men fighting in the Great War. In both Europe and North America, with the invention of the typewriter, office work became one of the few socially acceptable occupations for single middle-class women. ❧ These advertising ephemera also reflect their national origins. British Victorian advertising visually documents the stratified class structure of "upstairs, downstairs." The lady of the house is targeted as one who is in control or is to be taken care of, as well as the one who buys products intended specifically for her servants. In American advertising of the time, the scenes reflect more middle-class values, with the lady of the house often working together with her servant or else doing the work herself. These social differences are also evident in the art. British Victorian advertising is generally more elegant, showing the influence of the Continental *art nouveau* style, while the American ephemera is, by and large, more unsophisticated, permitting middle-class women to identify with the women depicted. ❧ Marketing concepts and techniques were introduced that are still in use today: the use of seductive female figures in ads to promote products aimed at the male audience, such as tobacco and men's wearing apparel; the creation of a need for new products; the promise that owning these new products will provide comfort and respectability for the family; the engendering of fear of inadequacy and failure for the woman

who refuses to buy these products; the implication that her leisure time will be increased, allowing her time to enhance her physical appearance. This new consumerism introduced the now accepted marketing technique of creating company images and recognizable brand names that promote the idea that work done *with* the advertised product is more valuable than work done *without* it. ❋ It was hard for the Victorian woman to be an individual. Her world was defined not only by the popular household instruction manuals, but also by the promoters of the new inventions and domestic supplies. A rich social history is embedded in late Victorian advertising ephemera, which provides visual documentation of the new technologies and the old conventions and how they affected each other. This vigorous period continues to provoke reevaluation, and it is only recently that serious research has concentrated specifically on the lives and expectations of everyday Victorian women. ❋ ❋ In the late Victorian years, trade cards, about postcard-size and often printed in the thousands, were the most common form of advertising for new products, services, and merchants. Distributed free of charge, often enclosed with the product or in a magazine, sometimes as a series, they were frequently collected into albums. The color medium most commonly used for advertising ephemera in all its forms was chromolithography, a printing technique using at least three and up to twenty lithographic stones, each for a different color, each requiring precise alignment over the others. Chromolithography, remarkable for its range of rich colors, was also the medium for the inexpensive mass-produced color reproductions of popular paintings bought by middle-class Victorians to decorate their homes. Replaced around the turn of the century by photolithography and other cheaper printing technologies, chromolithography is greatly underappreciated today. ❋

THE WORD "PURITY," MARKETED TO BE IDENTIFIED WITH THIS PRODUCT, HAS BOTH LITERAL AND FIGURATIVE MEANINGS, SINCE, TO THE VICTORIAN, PHYSICAL CLEANLINESS WAS SYNONYMOUS WITH MORAL INNOCENCE AND IDEAL FEMININITY. A SUCCESSFUL MARKETING IMAGE CAN BE TIMELESS.

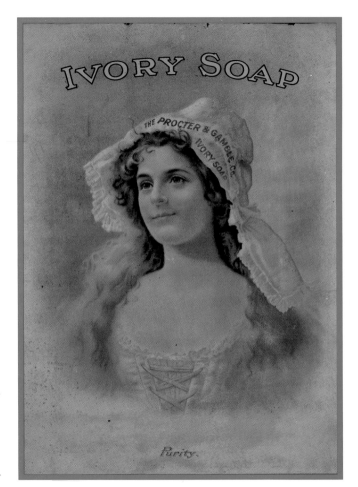

JANUARY

1

2

3

4

5

6

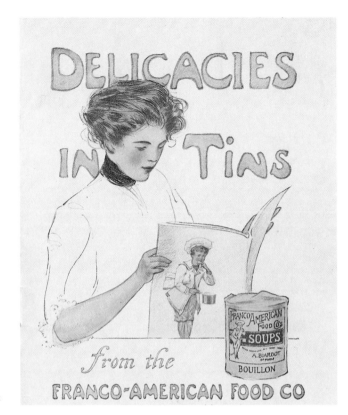

THOUGH CANNED FOOD WAS AVAILABLE ONLY TO THE MILITARY AT THE TIME OF THE CIVIL WAR, BY THE END OF THE CENTURY A GREAT VARIETY OF PROCESSED FOODS HAD BECOME STAPLES IN THE URBAN VICTORIAN DIET. ADVERTISERS CONCENTRATED ON WOMEN'S MAGAZINES, AND THEY FREELY DISTRIBUTED RECIPE BOOKLETS.

JANUARY

7

8

9

10

11

12

JANUARY

13

14

15

16

17

18

Calendar. 1883. (Printer: August Gast & Co., Litho.) Smithsonian Institution, Warshaw Collection of Business Americana

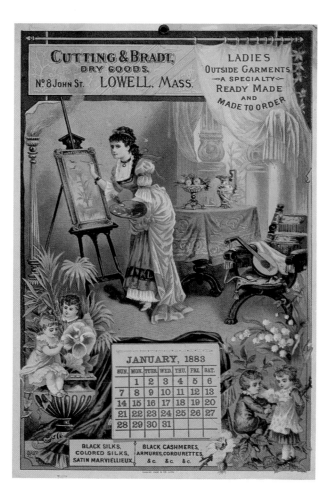

SINCE THE VICTORIAN
WOMAN HAD TO PROVIDE
THE CULTURAL TONE FOR
THE HOME, PAINTING AND
THE OTHER ARTS, SO LONG
AS THEY REMAINED AMA-
TEUR PURSUITS, WERE
EXPECTED WAYS FOR HER
TO SPEND HER LEISURE
TIME.

19

20

21

22

23

24

TRADE CARD. CIRCA 1889.

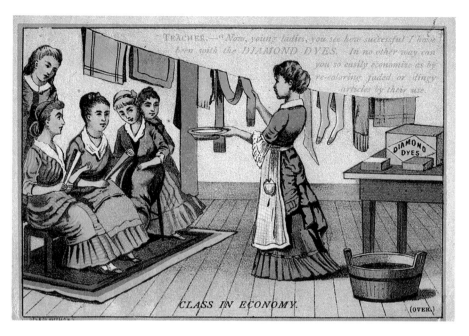

TEACHER.—"Now, young ladies, you see how successful I have
been with the DIAMOND DYES. In no other way can
you so easily economize as by
re-coloring faded or dingy
articles by their use.

CLASS IN ECONOMY.

(OVER.)

THE NEW WORLDS OF
INDUSTRY AND SCIENCE
WERE THE MODELS FOR
DOMESTIC SCIENCE, LATER
CALLED HOME ECONOMICS,
DEVELOPED BY THE EDUCA-
TOR CATHERINE BEECHER.
SHE BELIEVED THE EMPHA-
SIS ON ORGANIZATION AND
EFFICIENCY ENABLED THE
HOUSEWIFE TO HAVE STA-
TUS AS THE "MANAGER" OF
HER HOME.

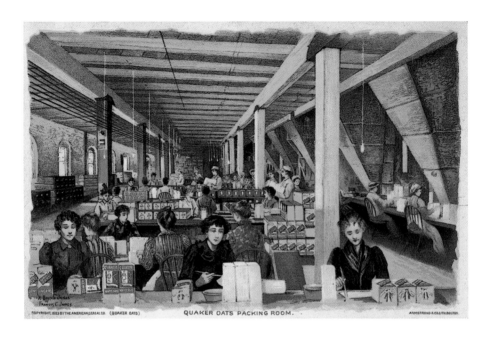

QUAKER OATS PACKING ROOM.

COPYRIGHT, 1893 BY THE AMERICAN CEREAL CO. (QUAKER OATS) ARMSTRONG & CO. LITH. BOSTON.

IN CONTRAST TO THE ISO-
LATION AND SERVITUDE OF
DOMESTIC WORK, THE COM-
PANIONSHIP OF OTHER
WOMEN MADE FACTORY
WORK APPEALING.

JANUARY

	25
	26
	27
	28
	29
	30 *31*

"... The Machine
should ... be complete
in those automatic
devices which lighten
the labours, increase
the speed, and gladden
the hearts of Type-
writer operators...."

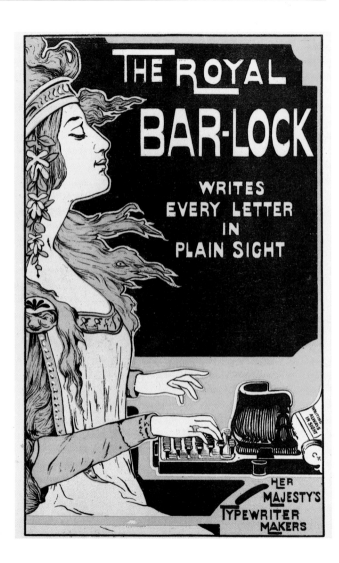

FEBRUARY

1

2

3

4

5

6

Leaflet cover. Circa 1898. John Johnson
Collection, Office Equipment 3, Bodleian
Library, Oxford

7

8

9

10

11

12

L ABEL. CIRCA 1885. COLLECTION SUSAN W. AND
STEPHEN D. PAINE

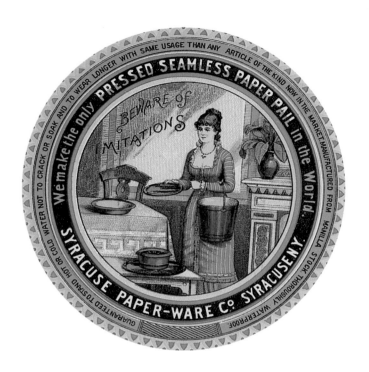

A NEW PRODUCT DESIGNED
FOR THE HOUSEWIFE TO DO
HER OWN CLEANING.

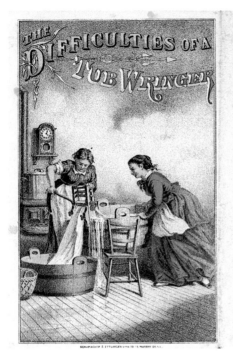

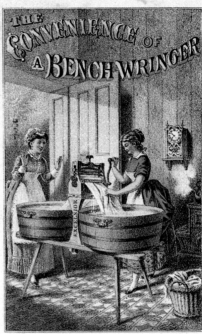

"WITH THE EXCELSIOR
YOU CAN STAND ERECT IN
WRINGING, AND . . . YOU CAN
WRING FROM EITHER TUB
BY MEANS OF THE TIPPING
WATER BOARD. . . ." NOTE
THE HOUSEWIFE WORKING
TOGETHER WITH HER SER-
VANT IN THIS AMERICAN AD.

FEBRUARY

13

14

15

16

17

18

Pamphlet covers. 1875–1880. (Printer: Schumacher & Ettlinger Litho., N.Y.) Collection Sharon and Daniel Kleitman

19

20

21

22

23

24

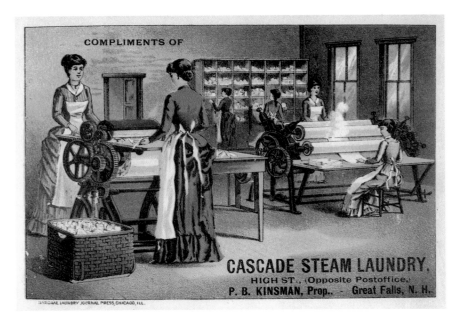

THE MOST ONEROUS OF HOUSEHOLD TASKS MOVED OUT OF THE HOME FOR SEVERAL DECADES INTO COMMERCIAL LAUNDRIES, STAFFED BY SINGLE WOMEN. BUT THE STEAM LAUNDRIES WERE FINALLY DISPLACED BY THE MORE PROFITABLE HOME WASHING MACHINE INDUSTRY, AND HEAVY LAUNDRY MOVED BACK INTO THE HOME.

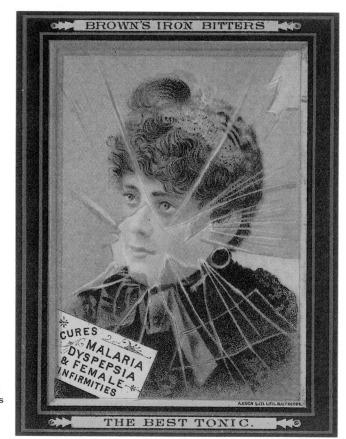

THE BEST TONIC.

THE ILLNESSES NAMED HERE WERE CODE WORDS FOR THE PRIMARY VICTORIAN MIDDLE-CLASS FEMALE COMPLAINT— NEURASTHENIA—MARKED BY FATIGUE AND FEELINGS OF INADEQUACY. IT WAS WIDELY TREATED BY PATENT MEDICINES CONTAINING ALCOHOL AND OPIUM. THE ENSUING DEPENDENCE ON THOSE DRUGS SERVED AS PROOF OF WOMAN'S WEAKNESS— AND HER NEURASTHENIA.

FEBRUARY

	25
	26
	27
	28
	29

TRADE CARD. 1890–1895. (PRINTER: A. HOEN & CO., BALTIMORE)

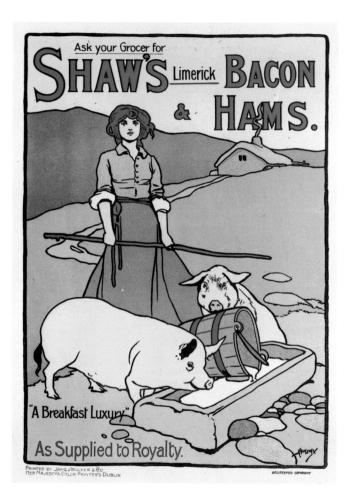

JOHN HASSALL, THE
FAMOUS BRITISH POSTER
ARTIST, DESIGNED THIS
EFFECTIVE POSTER.

MARCH

1

2

P.E.O. Thurs
3

4

5

6

7

8

9

10

11

Sat
12

Mc Arthy wedding 2p.

POSTER. CIRCA 1895.
COLLECTION WILLIAM H. HELFAND, USA

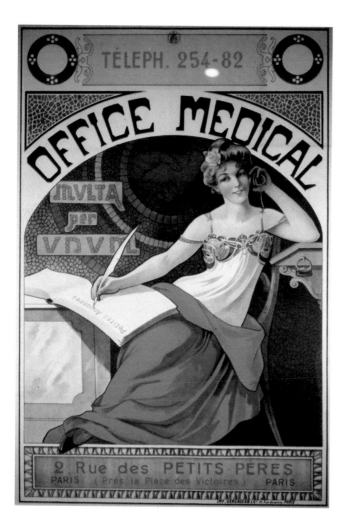

AN EARLY EXAMPLE OF USING THE TELEPHONE NUMBER AS WELL AS THE TELEPHONE ITSELF TO ADVERTISE A SERVICE, IN THIS CASE A GROUP MEDICAL PRACTICE IN PARIS.

THIS POSTER CLEARLY
ACKNOWLEDGES BOTH
THAT WOMEN HAD BECOME
CONSUMER POWERS AS
READERS AND AS POTEN-
TIAL ADVERTISERS AND
THAT NEWSPAPERS WERE
A MAJOR ADVERTISING
MEDIUM.

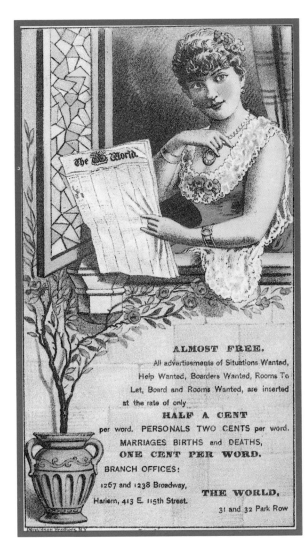

MARCH

13

14

15

16

17

18

MARCH

19

20

21

22

23

24

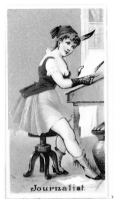

Journalist.

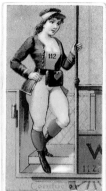

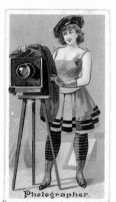

Scholar.

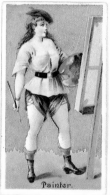

Painter.

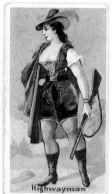

Highwayman

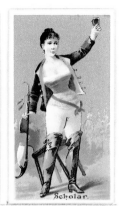

Photographer.

ORIGINALLY MADE TO
STIFFEN PACKAGES OF CIG-
ARETTES, INSERT CARDS
WERE THEN PRINTED IN
SERIES ESPECIALLY FOR
COLLECTING. IN THIS CASE
IT WAS A SERIES OF WOM-
EN'S "OCCUPATIONS."

THE MAJOR POSTER ARTIST LOUIS RHEAD, BORN IN ENGLAND IN 1857, CAME TO THE UNITED STATES IN 1883 AND EXHIBITED WIDELY IN AMERICA AND EUROPE. HE WON A GOLD MEDAL IN BOSTON IN 1895 FOR HIS POSTERS.

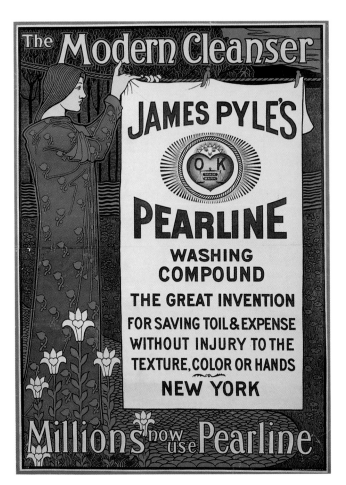

MARCH

25

26

27

28

29

30
31

1

2

3

4

5

6

COTTON SPINNING

PAMPHLET COVER. 1900. (PRINTER: J. OTTMANN, LITH., N.Y.)

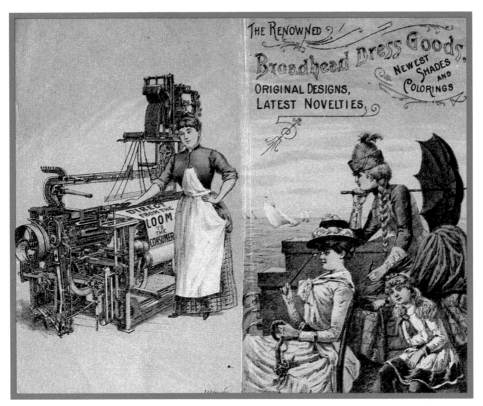

THE RENOWNED
Broadhead Dress Goods,
ORIGINAL DESIGNS,
LATEST NOVELTIES,
NEWEST SHADES AND COLORINGS

DIRECT FROM THE LOOM TO THE CONSUMER

HISTORICALLY, WOMEN HAVE ALWAYS BEEN THE PRIMARY SOURCE OF LABOR IN THE TEXTILE INDUSTRY. THIS EXAMPLE PRESENTS THE WOMAN AS BOTH PRODUCER AND CONSUMER OF THE PRODUCT.

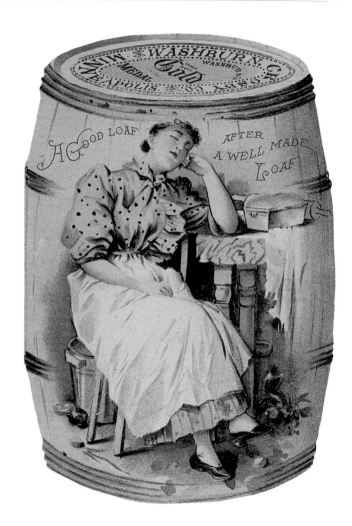

"GOOD BREAD IS THE
STAFF OF LIFE. TO MAKE IT
YOU NEED WASHBURN,
CROSBY'S CO.'S FLOUR."
AN EARLY ADVERTISEMENT
EMPHASIZING THE BRAND
NAME.

APRIL

7

8

9

10

11

12

TRADE CARD. DIE-CUT OF BARREL. CIRCA 1885.

THE FRONT OF THIS TRADE CARD SHOWS WOMEN SEWING THEIR OWN CLOTHES, AND THE REVERSE SIDE INDICATES THE PATTERN NUMBERS OF THE DRESSES THEY ARE WEARING.

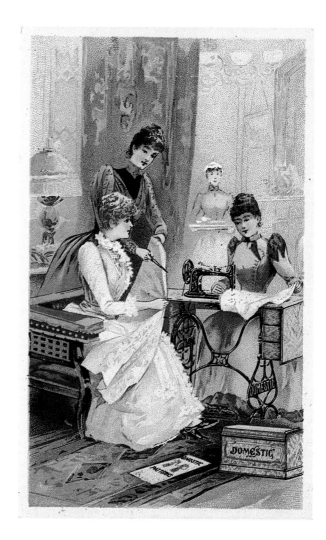

APRIL

13

14

15

16

17

18

Trade card. Circa 1890. Hallmark Historical Collection, Hallmark Cards, Inc.

19

20

21

22

23

24

TRADE CARD. CIRCA 1884. (PRINTER: MAYER, MERKEL & OTTMANN, LITH., N.Y.)

THE
EUREKA
COOKER
can be
RENTED
For a nominal
Quarterly sum
From the
GAS OFFICE

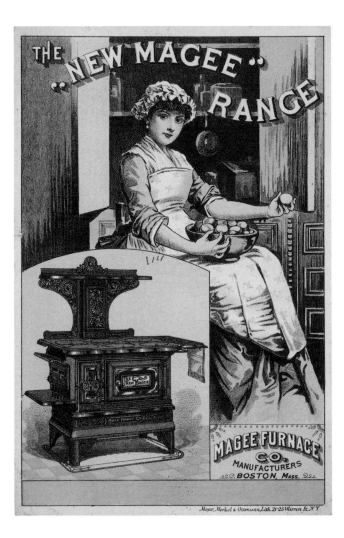

THE MOST IMPORTANT
TECHNOLOGICAL ADVANCE
OF THE 19TH CENTURY FOR
THE HOME WAS THE CAST-
IRON STOVE FOR HEATING
AS WELL AS COOKING.
WOMEN WERE RESPON-
SIBLE, HOWEVER, FOR
CARRYING AND STOKING
THE FUEL IN ADDITION TO
PREPARING ELABORATE
MEALS USING THE COMPLI-
CATED DAMPERS. THE
STOVE WAS SOLD ON THE
INSTALLMENT PLAN TO
MARKET IT MORE WIDELY.

25

26

27

28

29

30

TRADE CARD. 1899. (PRINTER: J. OTTMANN
LITH. CO., N.Y.)

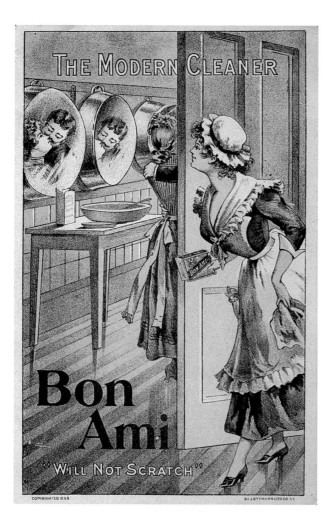

MAY

1

2

3

4

5

6

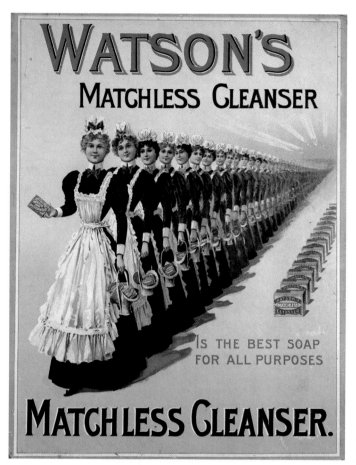

USING VISUAL REINFORCE-
MENT, THIS IS A STRIKING
EXAMPLE OF AN ADVER-
TISEMENT AIMED AT THE
LADY OF THE HOUSE TO
PROVIDE A PRODUCT TO BE
USED BY HER SERVANTS.

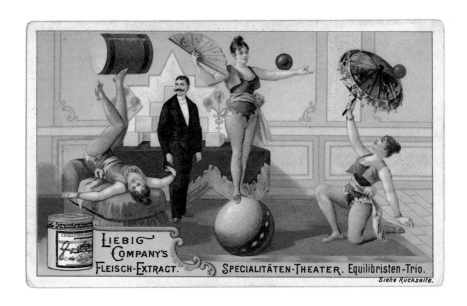

LIEBIG COMPANY'S FLEISCH-EXTRACT. SPECIALITÄTEN-THEATER. Equilibristen-Trio.

Siehe Rückseite.

ONE OF A SERIES DEPICT-
ING THEATRICAL ACTS.
MANY SERIES OF DIFFER-
ENT SUBJECTS WERE
PRINTED IN SEVERAL
COUNTRIES TO BE COL-
LECTED, THUS ENCOUR-
AGING CONTINUED
PURCHASING.

MAY

7

8

9

10

11

12

Trade card. 1894. (Publishers: Liebig's Company, Antwerp)

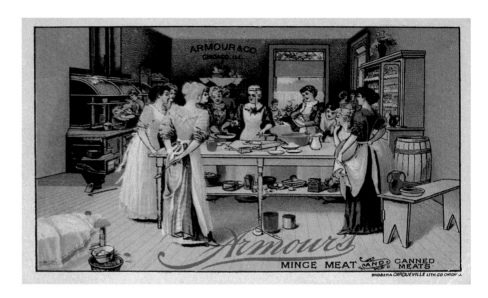

ONE OF THE MAJOR
EFFECTS OF THE DOMESTIC
SCIENCE MOVEMENT WAS
THE GROWTH OF COOKING
SCHOOLS, EDUCATING
WOMEN OF ALL CLASSES
ABOUT THE CHEMISTRY OF
COOKING AND THE NEW
SCIENCE OF NUTRITION.
MANY OF THE NEW PRO-
CESSED FOODS WERE
INCLUDED IN THE
SCHOOLS' MENUS.

MAY

13

14

15

16

17

18

Trade card. 1885–1890. (Printer: Shober & Carqueville Lith Co., Chicago)

"... It is unquestionably one of the best blood purifiers in the world, and for kidney disease it has no equal." One expression of the upper-middle-class Victorian woman's refinement and femininity was her delicate health.

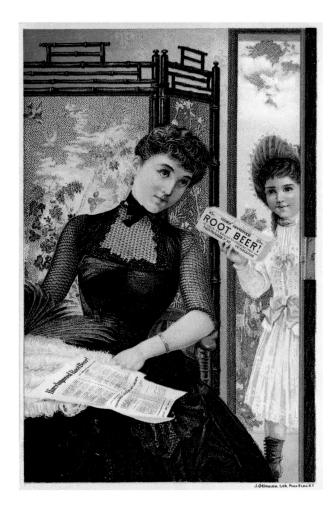

MAY

19

20

21

22

23

24

25

26

27

28

29

30
31

TRADE CARD. 1890–1895.
COLLECTION WILLIAM H. HELFAND, USA

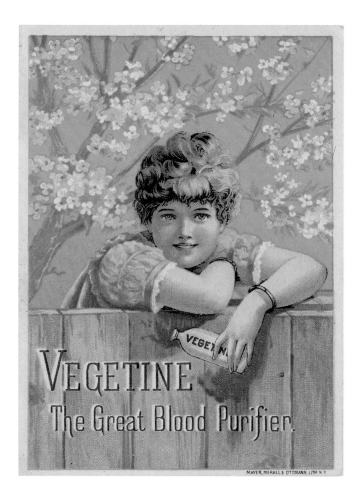

"THE MAIDEN WITH THE LAUGHING EYES AND ROSY CHEEKS — A PICTURE OF HEALTH — IS OFFERING YOU **VEGETINE**, THE MOST RELIABLE VITALIZER OF THE HUMAN BLOOD.... IS IT NOT WISE TO HEED THE WARNING SYMPTOMS SHOWN BY LANGOUR, 'THAT TIRED FEELING,' HEADACHE, INDIGESTION, SALLOW COMPLEXION AND NERVOUS DEBILITY?..."

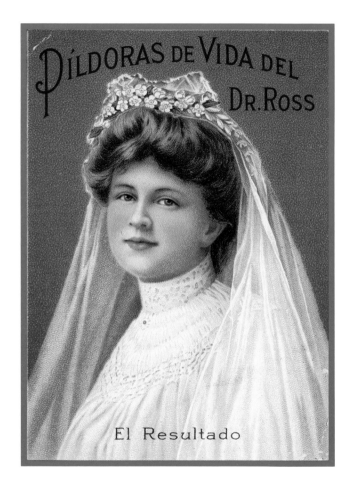

PILDORAS DE VIDA DEL DR. ROSS

El Resultado

EVEN IN SPANISH, IT IS
CLEAR THAT "THE PILLS
OF LIFE" ARE AIMED AT
THE SAME GOAL THAT WAS
SUPPOSED TO MOTIVATE
ENGLISH-SPEAKING VICTO-
RIAN WOMEN: MARRIAGE.

JUNE

	1
	2
	3
	4
	5
	6

TRADE CARD. CIRCA 1900.
COLLECTION WILLIAM H. HELFAND, USA

THE RUMPLED NIGHT-
GOWN, THE REMOTE
SETTING, AND THE REFLEC-
TIONS OF THE WOMAN'S
LEGS IN THE WATER
TRANSFORMED THE VIC-
TORIAN VIEWER INTO A
VOYEUR.

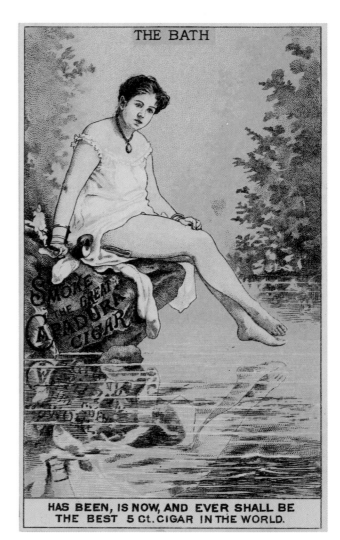

JUNE

7

8

9

10

11

12

13

14

15

16

17

18

TRADE CARD. 1891. (PRINTER: DONALDSON BROS.,
N.Y.) COLLECTION SUSAN W. AND STEPHEN D. PAINE

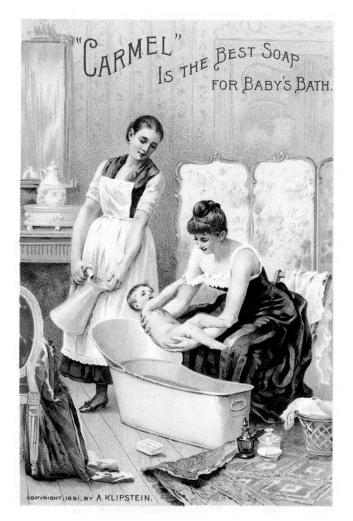

"AT THE FOOT OF MT. CAR-
MEL, A MISSION SOCIETY
HAS TAKEN ADVANTAGE OF
THE SUPERIOR OLIVE OIL
MADE IN PALESTINE, TO
SUPPORT ITSELF BY THE
MANUFACTURE OF AN
EXCEPTIONALLY FINE
OLIVE OIL TOILET
SOAP...."

THIS AD IMPLIES AN
ENDORSEMENT BY THE
VICTORIAN MEDICAL
ESTABLISHMENT. A NEW
PROCEDURE TO PREVENT
INFECTION, PIONEERED BY
JOSEPH LISTER IN THE
OPERATING ROOM IN 1875
AND USED THROUGHOUT
THE HOSPITAL BY
1890, USED CARBOLIC
ACID (PHENOL) AS AN
ANTISEPTIC. CLEARLY, IF
IT SANITIZES THE HOSPI-
TAL, IT SANITIZES THE
HOME. FOR THE VICTO-
RIAN, CLEANLINESS WAS
NEXT TO GODLINESS.

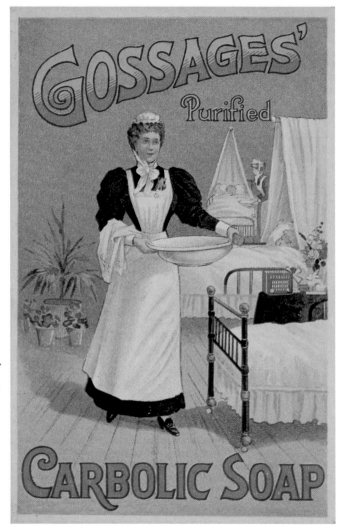

JUNE

19

20

21

22

23

24

25

26

27

28

29

30

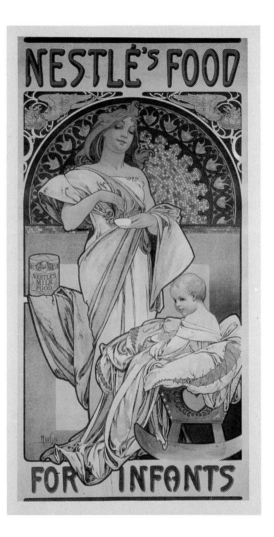

THE CZECH ARTIST
ALPHONSE MUCHA MADE
ADVERTISING INTO AN ART
MEDIUM.

TO PROMOTE THIS CUFF-
AND-COLLAR BUTTON TO
VICTORIAN MEN, THE
ADVERTISERS EXPLOITED
THE EROTIC POSSIBILITIES
OF THIS DARING DISPLAY
OF ANKLES AND BARE
SHOULDERS.

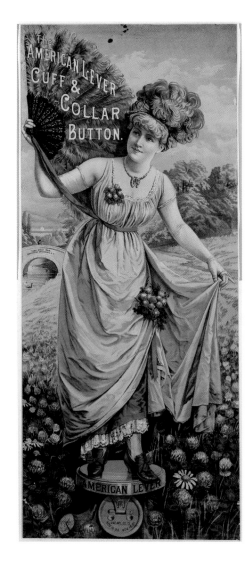

JULY

1

2

3

4

5

6

7

8

9

10

11

12

DISPLAY CARD. CIRCA 1900. WALTHAM WATCH CO. COLLECTION, BAKER LIBRARY, MANUSCRIPTS AND ARCHIVES, HARVARD GRADUATE SCHOOL OF BUSINESS ADMINISTRATION, BOSTON

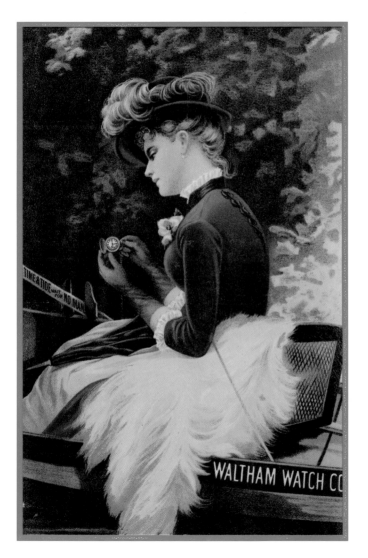

WAS THIS CONVENTION-
ALLY DRESSED WOMAN
PREPARED TO BEHAVE
UNCONVENTIONALLY,
AS SUGGESTED BY THE
IDYLLIC BUT ISOLATED
SETTING?

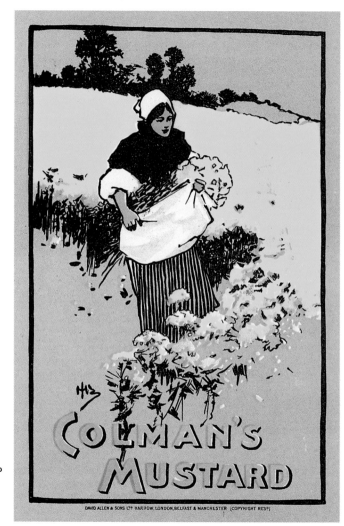

ENTITLED "THE MUSTARD
GIRL," THIS IS ONE OF
JOHN HASSALL'S MOST
FAMOUS POSTERS.

July

13

14

15

16

17

18

Poster. Circa 1900. (Printer: David Allen & Sons, Ltd., Harrow, London, Belfast & Manchester)

19

20

21

22

23

24

TRADE CARD. CIRCA 1895. COLLECTION SUSAN W. AND
STEPHEN D. PAINE

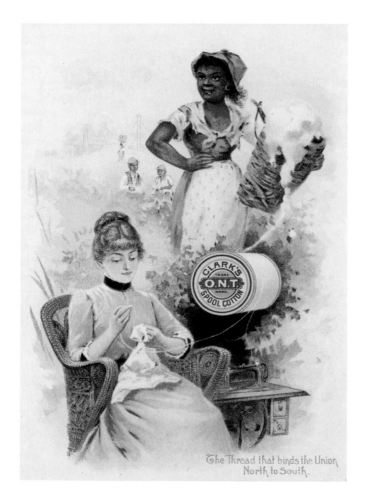

The Thread that binds the Union North to South.

UNLIKE THIS RESPECTFUL TRADE CARD, MOST VICTORIAN ADVERTISEMENTS WERE DEMEANING TO ETHNIC AND RACIAL MINORITIES.

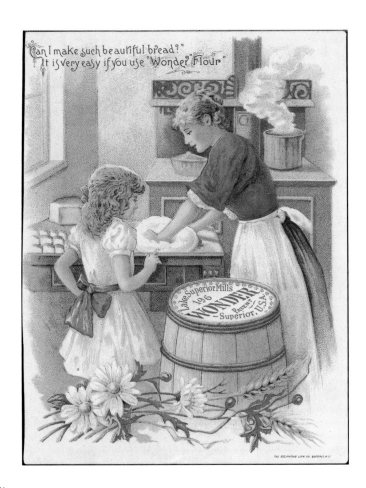

A RECURRING THEME IN
ADVERTISING IS MOTHER
TEACHING DAUGHTER
"WOMEN'S WORK."

JULY

25

26

27

28

29

30
31

MAGAZINE INSET. CIRCA 1895. (PRINTER: THE RICHMOND LITH. CO., BUFFALO, N.Y.)

THE ADVERTISEMENT
IMPLIES THAT THIS NEW
INVENTION IS SO EASY TO
OPERATE THAT EVEN A
GIRL CHILD CAN USE IT.

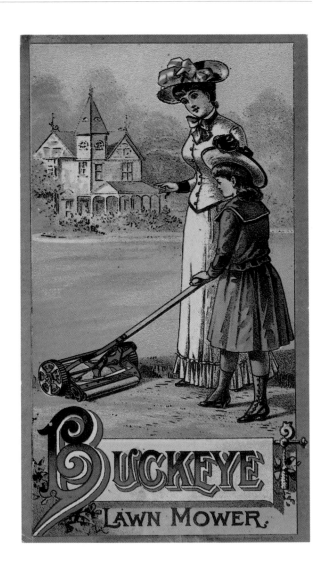

AUGUST

1

2

3

4

5

6

TRADE CARD. CIRCA 1895. (PRINTER: THE HENDERSON-ACHERT LITHO. CO., CINCINNATI)

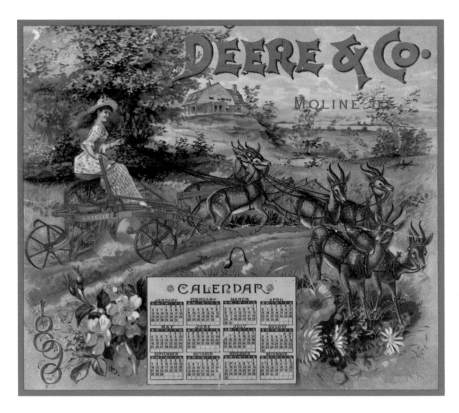

BECAUSE IT IS DRIVEN BY
A CHARMING YOUNG
WOMAN, THE AD IMPLIES,
THIS SEED DRILL WITH A
HARROW IN THE REAR
MUST BE SIMPLE TO USE.

AUGUST

7

8

9

10

11

12

CALENDAR. 1890. (PRINTER: SACKETT, WILHELMS LITHO CO., N.Y.) COURTESY DEERE & COMPANY

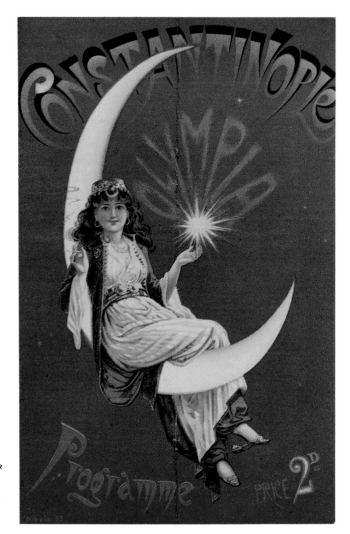

"OLYMPIA," LONDON'S CHIEF EXHIBITION CENTER FOR NEW TECHNOLOGIES, WAS ITSELF A PIONEER IN THE USE OF ELECTRIC ARC LIGHTING.

August

13

14

15

16

17

18

Exhibition Hall Program Cover. 1893. John Johnson Collection, Exh. Cat. 13, Bodleian Library, Oxford

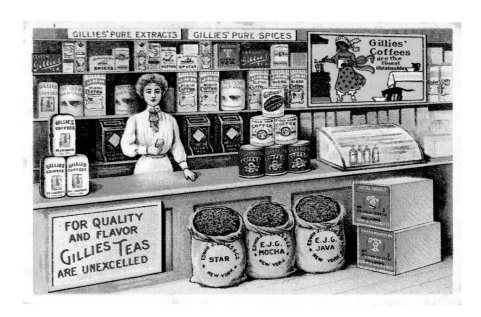

THIS DEPICTION OF A
WOMAN SALES CLERK DOC-
UMENTS THE TRANSITION
BETWEEN FOOD SOLD IN
BULK AND THE MANY VARI-
ETIES OF PREPACKAGED
FOODS EMPHASIZING THE
BRAND NAME.

AUGUST

19

20

21

22

23

24

TRADE CARD. 1880–1890. COLLECTION SUSAN W. AND
STEPHEN D. PAINE

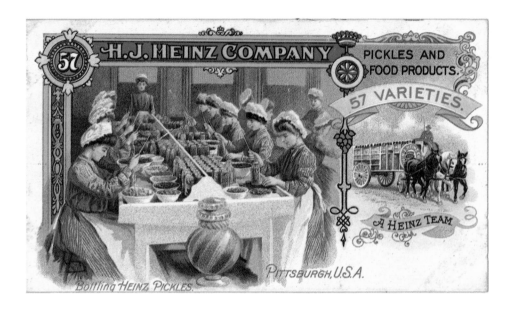

Bottling Heinz Pickles.

By the turn of the century, food processing was a well-established industry; women as assembly-line workers connoted cleanliness and purity.

AUGUST

25

26

27

28

29

30

31

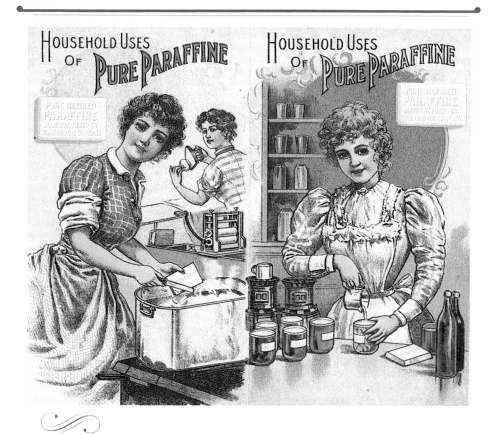

A PETROLEUM PRODUCT, PARAFFIN WAS FIRST PRODUCED COMMERCIALLY IN 1867, LESS THAN 10 YEARS AFTER THE FIRST OIL WELL WAS DRILLED. PRECIPITATED EASILY FROM FUEL OIL BY CHILLING, THE PARAFFIN WAS USEFUL IN KITCHEN AND LAUNDRY.

SEPTEMBER

1

2

3

4

5

6

PAMPHLET COVER. 1885–1890.

COLLECTION SUSAN W. AND STEPHEN D. PAINE

THIS AD CAPITALIZES ON THE NEWLY INVENTED BICYCLE TO IMPLY THAT THE WOMAN WHO BUYS PREPACKAGED BAKED GOODS, AS OPPOSED TO BAKING THEM HERSELF, HAS THE FREEDOM AND MOBILITY SUGGESTED BY THE BICYCLE.

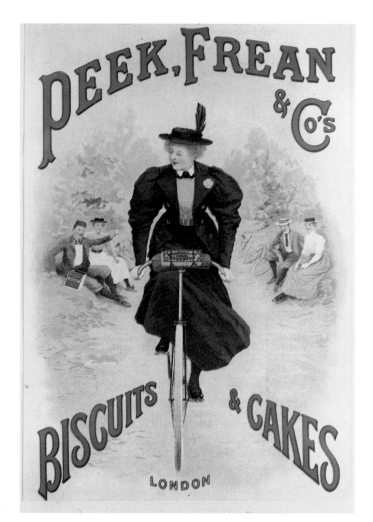

SEPTEMBER

7

8

9

10

11

12

September

13

14

15

16

17

18

PAMPHLET ILLUSTRATIONS. CIRCA 1900. COLLECTION
SUSAN W. AND STEPHEN D. PAINE

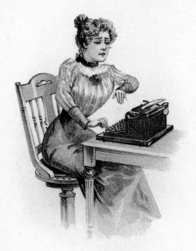

You cannot afford to do your writing in the old way,

The old standard of efficiency,
Work! Work! Work!

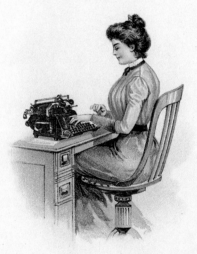

But you need an Electric Blickensderfer with writing in sight.

The new standard of efficiency,
Touch the key, Electricity does the work.

THE TYPEWRITER PRO-
VIDED NEW SOCIALLY
ACCEPTABLE OCCUPATIONS
FOR MIDDLE-CLASS SINGLE
WOMEN.

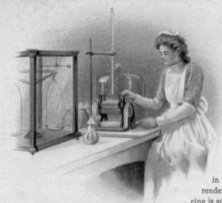

TOWARD THE END OF THE LAST CENTURY THERE WAS SUCH STRONG RESISTANCE TO VACCINATION IN THE UNITED STATES THAT ONLY 18 STATES REQUIRED IT. IN MOST EUROPEAN COUNTRIES, HOWEVER, IT WAS COMPULSORY. THIS TRADE CARD, ONE OF A SERIES, DESCRIBED THE PRODUCTION PROCEDURES AND SERVED TO EDUCATE AND REASSURE THE PUBLIC AS TO THE SAFETY OF THE VACCINE.

SEPTEMBER

19

20

21

22

23

24

JEYES' DISINFECTANTS

43. CANNON ST. LONDON.

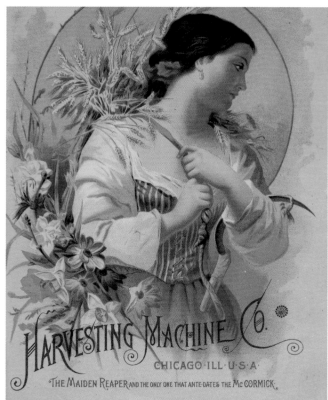

USING THE IMAGE OF A
SWEET FARM GIRL REAP-
ING BY HAND, THIS AD
FOR THE MCCORMICK
HARVESTING MACHINE
COMPANY IS TAKING
PROPER CREDIT FOR
THE FIRST MECHANICAL
REAPER, THE MOST IMPOR-
TANT AND SUCCESSFUL
AGRICULTURAL INVENTION
OF THE 19TH CENTURY.
THE COMPANY HAD SOLD
ALMOST 55,000 MACHINES
BY 1884.

SEPTEMBER

25

26

27

28

29

30

DISPLAY CARD. CIRCA 1885. SMITHSONIAN
INSTITUTION, WARSHAW COLLECTION OF
BUSINESS AMERICANA

THIS CHOCOLATE COMPANY INSERTED CARDS DOCUMENTING DIFFERENT INDUSTRIES INTO PACKAGES OF CHOCOLATE. ILLUSTRATING THE MANUFACTURE OF PORCELAIN, THIS CARD SHOWS WOMEN CARRYING TUBS OF KAOLIN, A CLAY, FROM A QUARRY.

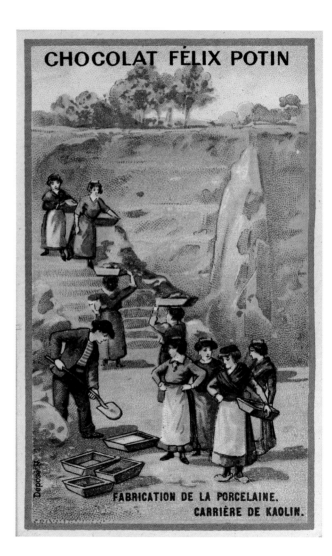

CHOCOLAT FÉLIX POTIN

FABRICATION DE LA PORCELAINE.
CARRIÈRE DE KAOLIN.

OCTOBER

1

2

3

4

5

6

P ACKAGE INSERT CARD. CIRCA 1900. JOHN JOHNSON
COLLECTION, CHOCOLATE AND CONFECTIONERY,
BODLEIAN LIBRARY, OXFORD

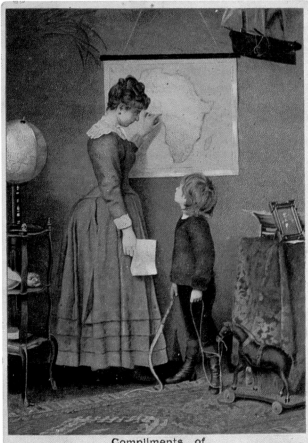

Compliments of
QUIRI & CLARK,
10 Market St., AMSTERDAM, N. Y.

ONE EXPECTATION OF THE
MOTHER IN HER ROLE AS
TEACHER WAS PREPARING
HER SONS FOR A FUTURE
IN THE AGGRESSIVE MALE
WORLD OF COMMERCE.

OCTOBER

7

8

9

10

11

12

TRADE CARD. CIRCA 1891.

13

14

15

16

17

18

POSTER. CIRCA 1895. ARTIST: ADOLPH HOHENSTEIN.
(PRINTER: REVERCHON, TOULOUSE AND PARIS)
COLLECTION WILLIAM H. HELFAND, USA

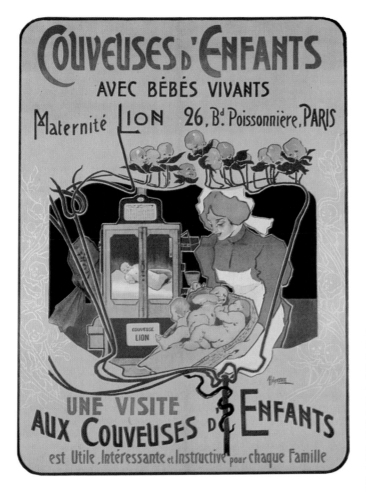

THE FIRST CLOSED INCU-
BATOR, A "COUVEUSE,"
WAS INVENTED IN 1881 BY
STÉPHANE TARNIER IN
THE MATERNITÉ HOSPI-
TAL, PARIS. THIS POSTER,
IN CLASSIC ART NOUVEAU
STYLE BY THE WELL-
KNOWN ARTIST ADOLPH
HOHENSTEIN, IS
ANNOUNCING A PUBLIC
EXHIBITION DISPLAYING
THE INCUBATOR WITH
LIVING BABIES, AS
"USEFUL, INTERESTING,
AND INSTRUCTIVE FOR
EACH FAMILY."

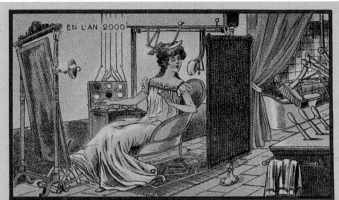

Madame à sa Toilette.

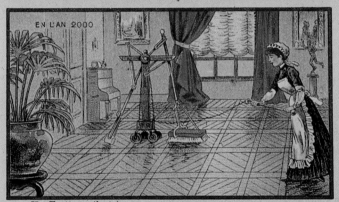

Un Frotteur électrique.

VICTORIAN VISIONS OF
WOMEN'S LIVES IN THE
YEAR 2000.

OCTOBER

19

20

21

22

23

24

MATCHBOX LABELS. CIRCA 1900. PRIVATE COLLECTION.
 (PHOTO: MICHAEL HOLFORD)

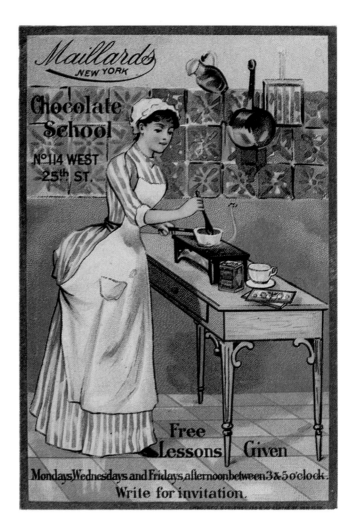

OCTOBER

25

26

27

28

29

30

31

TRADE CARD. CIRCA 1890. (PRINTER: GEO. SCHLEGEL, N.Y.)

"FIVE WALLS TO PRESERVE THE ICE, AIR TIGHT LOCKS, SOLID IRON SHELVES, AIR FLUES REMOVABLE FOR CLEANLINESS, REAL BRONZE TRIMMING...."

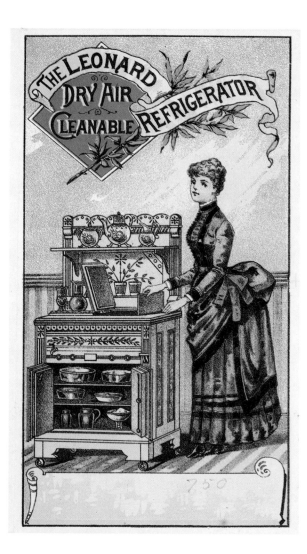

NOVEMBER

1

2

3

4

5

6

PAMPHLET COVER. CIRCA 1888. (PRINTER: THE
CALVERT LITHO. CO., DETROIT) COLLECTION
SUSAN W. AND STEPHEN D. PAINE

"... IN THE UPPER RANKS OF SOCIETY ... THE FAIRER SEX ARE PARTICULARLY PRONE TO NEGLECT THE TAKING OF PROPER EXERCISE. ... THE HEALTH JOLTING CHAIR AFFORDS AN EXERCISE SIMILAR TO THAT GIVEN BY A SADDLE-HORSE. IT CAN BE REGULATED SO AS TO GIVE IT IN ANY DEGREE OF SEVERITY DESIRED; STRENGTHENING AND INCREASING THE ACTIVITY OF ALL ... ORGANS ... AND BEAUTIFULLY DEVELOPING THE ARMS, SHOULDERS AND CHEST. ..."

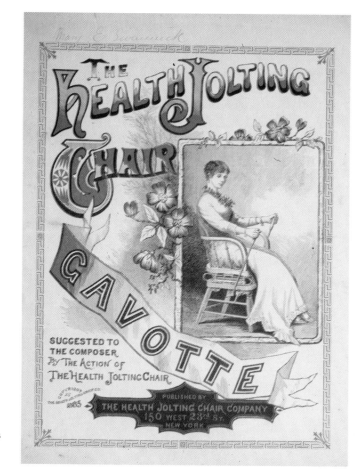

NOVEMBER

7

8

9

10

11

12

S ONG SHEET COVER, 1885. (PRINTER: PUTNAM'S
PRINT, N.Y.)
COLLECTION WILLIAM H. HELFAND, USA

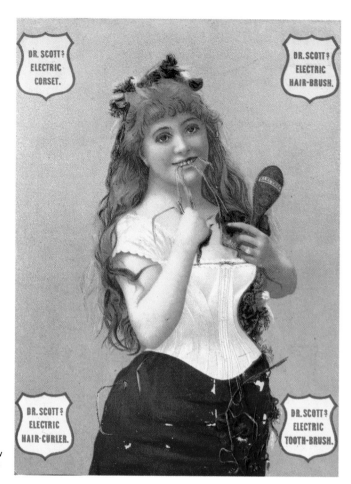

THE NOVELTY OF THE NEW
TECHNOLOGY—ELECTRIC-
ITY—WAS READILY
EXPLOITED FOR ANY AND
ALL PURPORTED HEALTH
AND BEAUTY AIDS.

November

13

14

15

16

17

18

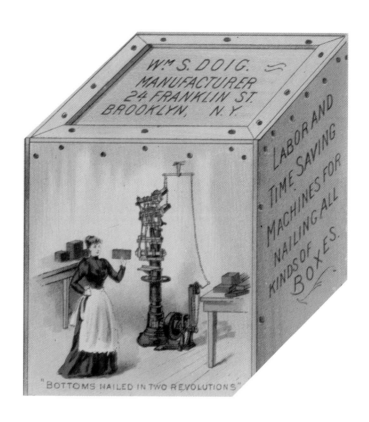

AN EXCELLENT EXAMPLE
OF ADVERTISING EPHEM-
ERA VISUALLY DOCUMENT-
ING THE FACT THAT VICTO-
RIAN WOMEN DID WORK IN
LIGHT INDUSTRY.

NOVEMBER

19

20

21

22

23

24

Trade card. Die-cut of box. Circa 1900. The
Metropolitan Museum of Art, Jefferson R.
Burdick Collection

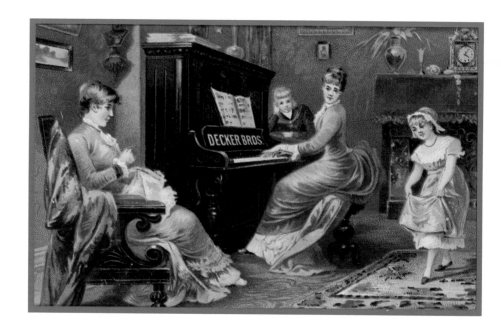

SINCE VICTORIANS PRI-
MARILY DEPENDED ON
THEMSELVES FOR THEIR
ENTERTAINMENT, MIDDLE-
CLASS HOMES WERE NOT
COMPLETE WITHOUT A
PIANO OR PARLOR ORGAN.

NOVEMBER

25

26

27

28

29

30

TRADE CARD. CIRCA 1894.

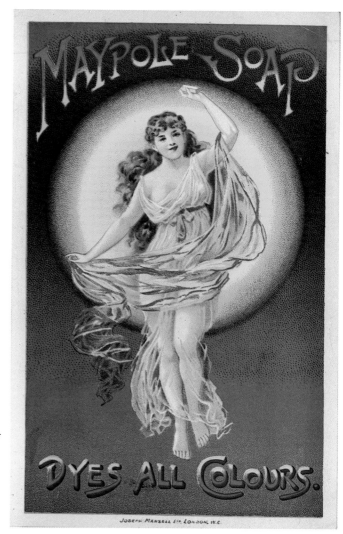

"... WILL DYE TO ANY SHADE, BUT WON'T WASH OUT OR FADE ... DOES NOT DYE THE HANDS" A PRACTICAL EXAMPLE OF ONE PRODUCT FOR THE HOME EMERGING FROM THE RAPIDLY EXPANDING CHEMICAL INDUSTRY.

December

1

2

3

4

5

6

Trade card. 1895–1900. (Printer: Joseph Mansell Ltd, London) John Johnson Collection, Soap 1, Bodleian Library, Oxford

DECEMBER

7

8

9

10

11

12

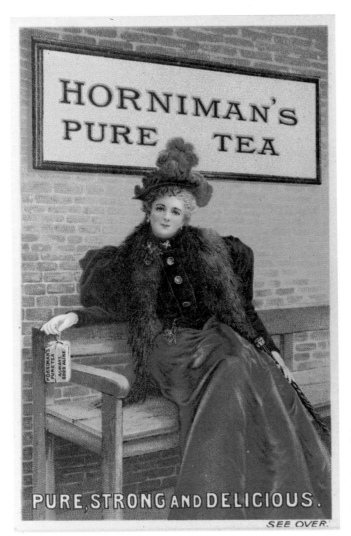

"QUALITY IS THE TRUE TEST OF CHEAPNESS. DO NOT ALLOW YOUR ANXIETY FOR CHEAPNESS BLIND YOUR EYES TO MERIT. . . . GUARANTEED PURE AND FULL WEIGHT WITHOUT THE PACKAGE. . . ."

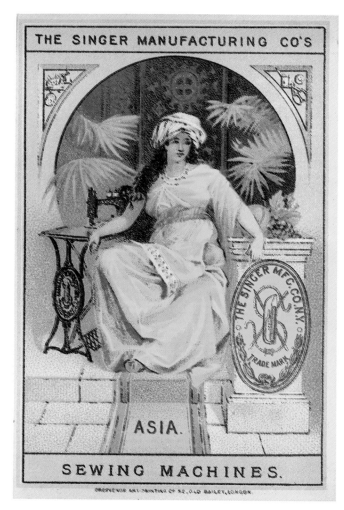

ONE OF A SERIES OF
CARDS ADVERTISING THIS
COMPANY'S WORLDWIDE
DISTRIBUTION.

DECEMBER

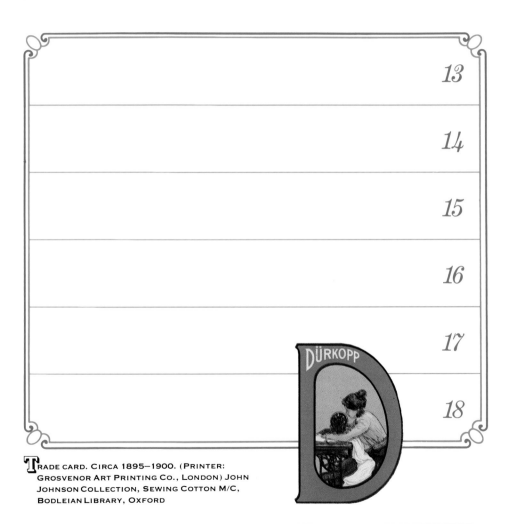

13

14

15

16

17

18

DÜRKOPP

TRADE CARD. CIRCA 1895–1900. (PRINTER:
GROSVENOR ART PRINTING CO., LONDON) JOHN
JOHNSON COLLECTION, SEWING COTTON M/C,
BODLEIAN LIBRARY, OXFORD

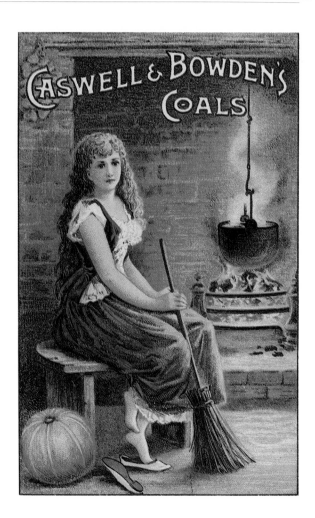

ENGLISH DOMESTIC
POSTAL RATES WERE
PRINTED ON THE REVERSE
OF THIS COMPLIMENTARY
CARD.

DECEMBER

19

20

21

22

23

24

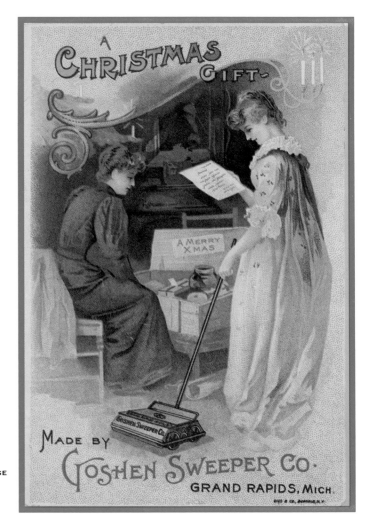

A CHRISTMAS GIFT

A MERRY XMAS

MADE BY GOSHEN SWEEPER CO.
GRAND RAPIDS, MICH.

PATENTED IN 1876, IN USE
SINCE THE 1880S, THE
CARPET SWEEPER HAS
REMAINED VIRTUALLY
UNCHANGED IN DESIGN.

DECEMBER

25

26

27

28

29

30
31

TRADE CARD. CIRCA 1897. (PRINTER: GIES & CO.,
BUFFALO)

Allen, Alistair, and Hoverstadt, Joan. *The History of Printed Scraps*. London: New Cavendish Books, 1983.

Beecher, Catherine E., and Stowe, Harriet Beecher. *The American Woman's Home: Or, Principles of Domestic Science* (1869). Hartford, CT: The Stowe-Day Foundation, 1985.

Beeton, Mrs. Isabella. *The Book of Household Management*. London: S. O. Beeton, 1861. A first-edition facsimile. New York: Farrar, Straus and Giroux, 1969.

Briggs, Asa, ed. *The Nineteenth Century*. London: Thames and Hudson, 1970.

Byrne, Janet S. *American Ephemera*. New York: Metropolitan Museum of Art, 1976.

Cate, Phillip, and Hitchings, Sinclair. *The Color Revolution*. Santa Barbara: P. Smith, 1978.

Cowan, Ruth Schwartz. *More Work for Mother: The Ironies of Household Technology from the Open Hearth to the Microwave*. New York: Basic Books, 1983.

Davidson, Caroline. *A Woman's Work Is Never Done: A History of Housework in the British Isles 1650–1950*. London: Chatto and Windus, 1982.

de Vries, Leonard. *Victorian Advertisements*. London: John Murray, 1968.

Ehrenreich, Barbara, and English, Deirdre. *For Her Own Good: 150 Years of the Experts' Advice to Women*. New York: Anchor Press/Doubleday, 1978.

Evans, Hilary, and Evans, Mary. *The Victorians: At Home and at Work*. New York: Arco Publishing Co., Inc., 1973.

Evans, Joan. *The Victorians*. Cambridge: Cambridge University Press, 1966.

Gay, Peter. *The Bourgeois Experience: Victoria to Freud*. Vol. 1, *Education of the Senses*. New York: Oxford University Press, 1984.

Green, Harvey. *The Light of the Home: An Intimate View of the Lives of Women in Victorian America*. New York: Pantheon Books, 1983.

Hibbert, Christopher. *The Horizon Book of Daily Life in Victorian England*. New York: American Heritage Publishing Co., Inc., 1975.

Jensen, Oliver, ed. *The Nineties*. New York: American Heritage Publishing Co., Inc., 1967.

John, Angela A., ed. *Unequal Opportunities: Women's Employment in England 1800–1918*. Oxford and New York: Basil Blackwell, Inc., 1986.

Kirsch, Francine. *Chromos: A Guide to Paper Collectibles*. New York: A. S. Barnes & Co., Inc., 1981.

Lewis, John. *Collecting Printed Ephemera*. London: Studio Vista, 1976.

McClinton, Katharine Morrison. *The Chromolithographs of Louis Prang*. New York: Clarkson N. Potter, Inc., 1973.

Marzio, Peter. *The Democratic Art: Chromolithography 1840–1900*. Boston: David Godine, and Forth Worth: The Amon Carter Museum, 1979.

Michie, Helena. *The Flesh Made Word: Female Figures, Women's Bodies*. New York: Oxford University Press, 1987.

Nevett, T. R. *Advertising in Britain: A History*. London: The History of Advertising Trust, William Heinemann Ltd, 1982.

Oakley, Ann. *Woman's Work: The Housewife, Past and Present*. New York: Pantheon Books, 1974.

Opie, Robert. *Rule Britannia: Trading on the British Image*. Hammondsworth and New York: Viking Penguin, Inc., 1985.

Pride, William M., and Ferrell, O. C. *Marketing*. Boston: Houghton Mifflin Co., 1985.

Rickards, Maurice. *This Is Ephemera: Collecting Printed Throwaways*. London: David & Charles, and Brattleboro: Stephen Greene Press, 1978.

Rothman, Sheila M. *Woman's Proper Place: A History of Changing Ideals and Practices, 1870 to the Present*. New York: Basic Books, 1978.

Shapiro, Laura. *Perfection Salad: Women and Cooking at the Turn of the Century*. New York: Farrar, Straus and Giroux, 1986.

Strasser, Susan. *Never Done: A History of American Housework*. New York: Pantheon Books, 1982.

This Fabulous Century: 1870–1900. New York: Time-Life Books, 1970.

Picture Credits for Details

Dedication page: Maurice Rickards Collection
February 1: John Johnson Collection, Office Equipment 3, Bodleian Library, Oxford
March 13 : John Johnson Collection, Advertising Printing, Bodleian Library, Oxford
April 19: John Johnson Collection, Cookery, Bodleian Library, Oxford
September 19: John Johnson Collection, Soap, Bodleian Library, Oxford
Colophon Page: Mary Evans Picture Library

Major Collections of Ephemera

American Antiquarian Society, Worcester, MA
Bethnal Green Museum of Childhood, London
Bodleian Library, John Johnson Collection, Oxford
Boston Public Library, Print Department, Boston, MA
Ephemera Society of America, Bennington, VT
Ephemera Society (UK), London
Hallmark Historical Collection, Hallmark Cards, Kansas City, MO
Library of Congress, Prints and Photographs Division, Washington, DC
Metropolitan Museum of Art, Jefferson R. Burdick Collection, New York, NY
Museum of American Textile History, North Andover, MA
Museum of the City of New York, New York, NY
New-York Historical Society, Bella C. Landauer Collection, New York, NY
New York Public Library, Print Department, New York, NY
Robert Opie Collection, London
Smithsonian Institution, Warshaw Collection of Business Americana, Washington, DC
Margaret Woodbury Strong Museum, Rochester, NY
Victoria and Albert Museum, London

Designed by Clifford Selbert
Production coordination by Amanda Freymann and Christina Holz
Composition in Stymie Open, Copperplate Gothic, and Century Schoolbook
by Monotype Composition Co.
Color separations, printing, and binding by Arcata Graphics/Kingsport

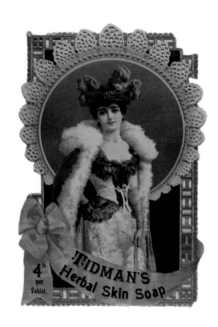